The Big Book of Little Sparks Creativity Journal

CARRIE BLOOMSTON

Illustrated by Ruth Burrows

stashBOOKS
an imprint of C&T Publishing

Text copyright

© 2022 by Carrie Bloomston

Publisher: Amy Barrett-Daffin

Creative Director: Gailen Runge

Senior Editor: Roxane Cerda

Editor: Liz Aneloski

Cover/Book Designer: April Mostek

Production Coordinator: Tim Manibusan

Production Editor: Jennifer Warren

Cover Illustrator: Ruth Burrows

Illustrator: Ruth Burrows

Photography Coordinator: Lauren Herberg

Photography Assistant: Gabriel Martinez

Photography by Carrie Bloomston,
unless otherwise noted

Published by Stash Books, an imprint
of C&T Publishing, Inc., P.O. Box 1456,
Lafayette, CA 94549

All rights reserved. No part of this work covered by the copyright hereon may be used in any form or reproduced by any means—graphic, electronic, or mechanical, including photocopying, recording, taping, or information storage and retrieval systems—without written permission from the publisher.

Attention Teachers: C&T Publishing, Inc., encourages the use of our books as texts for teaching. You can find lesson plans for many of our titles at ctpub.com or contact us at ctinfo@ctpub.com.

We take great care to ensure that the information included in our products is accurate and presented in good faith, but no warranty is provided, nor are results guaranteed. Having no control over the choices of materials or procedures used, neither the author nor C&T Publishing, Inc., shall have any liability to any person or entity with respect to any loss or damage caused directly or indirectly by the information contained in this book. For your convenience, we post an up-to-date listing of corrections on our website (ctpub.com). If a correction is not already noted, please contact our customer service department at ctinfo@ctpub.com or P.O. Box 1456, Lafayette, CA 94549.

Trademark (™) and registered trademark (®) names are used throughout this book. Rather than use the symbols with every occurrence of a trademark or registered trademark name, we are using the names only in the editorial fashion and to the benefit of the owner, with no intention of infringement.

Printed in the USA

THIS BOOK BELONGS TO

CONTENTS ♥

How to Use This Workbook 6
Introduction 7
What Is Your Learning Style?
Take This Fun Quiz! 8

SPARK 1 Just Start 12

SPARK 2 Create the Space 18

SPARK 3 Take a Class 22

SPARK 4 Negative Self-Talk 24

SPARK 5 Time 26

SPARK 6 Make a Huge Mess 28

SPARK 7 Permission 30

SPARK 8 Process 34

SPARK 9 Grace 36

SPARK 10 Break Your Own Rules 40

SPARK 11 Jar of Markers 42

SPARK 12 Go Window Shopping 46

SPARK 13 Get In Your Body 50

SPARK 14 Inner-Kid Care 54

- **SPARK 15** Doubt 62
- **SPARK 16** Have a Secret 66
- **SPARK 17** Inspiration 69
- **SPARK 18** The Pleasure Principle 70
- **SPARK 19** Make a Vision Board 72
- **SPARK 20** Create a Mission Statement 74
- **SPARK 21** Fear 78
- **SPARK 22** Find Your Voice 82
- **SPARK 23** Repetition 88
- **SPARK 24** Shine Your Light 92
- **SPARK 25** Make a Soul Box 94
- **SPARK 26** Take a Day Off 96
- **SPARK 27** Share Your Work 100
- **SPARK 28** Give It Away 106
- **SPARK 29** Leave It on the Field 108
- **SPARK 30** Be Your Own Unicorn 112
- **SPARK 31** Decenter Yourself 116
- **SPARK 32** Trust Yourself 122

Resources 124 About the Author 126

how to use this workbook

This is an interactive workbook designed to help you step into a creative life through engaging exercises, fun activities, inspirational images, and motivating ideas.

It will help you get to know yourself and your desires. You will learn what your little spark of passion, of creativity, looks like, how to capture it, and how to make space for it in your life.

Living a creative life means more than being an artist, writer, quilter, crafter, or chef. It is a way of living life with curiosity and openness. It means thinking from your heart, thinking for yourself, and thinking outside the box. In this workbook you'll learn how to make space for *you* in your life. You'll step into who you want to become and remember who you already are.

This is a journey into wonder and yourself. There are 32 Sparks in this workbook. You can do one a day for 32 days or one a week for 32 weeks. You can do them at any time and in any order. Do what works for you. As you explore each Spark, you'll be motivated, exhilarated, and brought in touch with yourself. You'll grow more confident about your ability and be ready to receive the gifts of a creative life—joy, connection, meaning, and contentment—gifts that come from doing something with passion. YOUR LITTLE SPARK WILL BE A HAPPY BONFIRE, BURNING BRIGHTLY IN YOU. IT WILL CHANGE YOUR LIFE.

If you want to read more of my insights about creativity, see The Little Spark—30 Ways to Ignite Your Creativity *(from C&T Publishing).*

INTRODUCTION

The Big Book of Little Sparks is a beginning, a seed, a whisper. It is an unanswered question—a nudge from your unconscious. It's a bit magical. It has a strange hold over you. It calls you with its siren song.

Your creativity is like a pilot light—it's always on, even if you aren't using the stove. And like the pilot light, it is fairly difficult to extinguish. It sits there at the center of who you are, and it waits. It may have been waiting a few months, a few years, or a few decades for you to see it. But it stayed lit until you noticed. Congratulations. You noticed. The Spark is your creativity, and you were born with it. We all were. One thing is certain: humans need to make things and record the contents of their hearts and minds.

YOUR DESIRE TO MAKE THINGS IS BIGGER THAN YOU. It is bigger than your daydreams. It comes from a part of you that laid on a rock and stared at the sky and wondered about why the stars shift and come back every night. It comes from our human desire to make things beautiful and meaningful—not for the sake of beauty, but because each decorative mark on that cake or that pot celebrates our existence. Each mark, each stitch, each crafted symbol etches your realness into your creations and into your life.

We all have to do something. If not, we'd be bored. Your Spark won't go away. It's a good thing you grabbed this journal, so you can honor the creative life waiting for you. You're ready to take a West African dance class, learn to play the oud, paint a self-portrait, design a website, take an online digital art class, sew a quilt, bead a necklace, blow a glass vase, write that first book, join the choir, braid some hemp, design a sustainable upcycled dress, plant a garden, or dye your own wool. Whatever it is, it will enrich and connect you. It will give your life depth. It will fill you with purpose and sparkle. It will allow you to shine your light. Let's get going.

WHAT IS YOUR LEARNING STYLE?

TAKE THIS FUN QUIZ!

1. You get a new piece of furniture from IKEA. YOU ➡

A. Carefully read the instruction manual and look at the diagrams, and then start building.

B. Ask someone you know to help you figure it out.

C. Push the manual aside as you reach for your tools to start assembling.

2. You are on a scenic leaf-peeping road trip and suddenly realize your cell phone, which contained the map app, died and you are lost. YOU ➡

A. Purchase a map at the first gas station you see.

B. Ask the first person you see how to get back to the highway.

C. Start driving and know that you'll figure it out by the road signs.

WHAT IS YOUR LEARNING STYLE? TAKE THIS FUN QUIZ!

3 You are shopping in Costco and you see a salesperson demonstrating a new blender. YOU →

A. Pay close attention to her as she uses the machine and then ask to see the box so you can look at the pictures.

B. Listen carefully to her words while trying to tune out that annoying loud whizzing sound.

C. Ask if you can have a turn trying it out for yourself.

4 It's time to plant the annual summer garden. YOU →

A. Pore over plant seed catalogs, magazines, and gardening books to get inspired.

B. Call your gardener friend and chat about what worked and what didn't work in her garden last year.

C. Head to the garden center to pick out a bunch of plants, mulch, and seeds, and then dig.

5 It is time to host your favorite cool new friends for dinner—and they are foodies! YOU →

A. Grab your best cookbooks and start dog-earing pages, and then go online to research more recipes from your favorite chefs.

B. Talk to your fishmonger to get advice about which fish to serve.

C. Just head into the kitchen and start playing with your haul from the farmers' market.

6 You have a big deadline coming up and are feeling a bit stressed. You need to figure out how to finish all your work, so you need a plan. YOU →

A. Write it all down on a piece of paper as a list and then maybe make a flowchart, timeline, or calendar to help you set your goals.

B. Seek advice from a friend and then repeat the steps in your mind until you feel comfortable.

C. Say, "Deadlines, schmeadlines! Who cares?" You are just going to start working and trust that you will get it all done in time.

TO FIND YOUR SCORE.

Put a **1** on the most likely, **2** on second and **3** at least likely.

If you answered mostly a, then you are a *visual learner*. You have to see it to get it! You want to be shown. You want charts, pictures, books, illustrations, maps, video tutorials, diagrams, and demos. You learn through observing the world with your eyes. If your teacher shows you something, you will watch her and then emulate her with your body until you understand.

If you answered mostly b, you are an *auditory learner*. You love a good lecture! You like to listen, chat, talk, share, and hear what others are saying. You love listening to your teacher's words, and you can understand it if someone says it to you rather than if someone shows you. Sometimes you talk to yourself to absorb the information by saying it out loud. It helps you learn.

If you answered mostly c, you are a *tactile/kinesthetic learner*. You aren't going to stop to read a manual! You won't be happy until you dig right in and get your hands dirty. You learn by doing it for yourself. You may make mistakes, but you will learn from them. You are going to figure it out. You have little patience for long-winded explanations because you just want to get going!

Now that you know your learning style, use it to help you as you explore, study, try new things, and create.

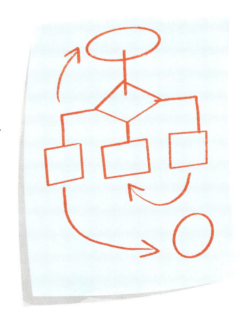

SPARK 1
JUST START

Beginning is the hardest part for many creatives.

I tend to procrastinate when starting any new project. Starting takes guts. My favorite advice on beginning comes from experimental composer John Cage, who advises us to "Begin anywhere." Where you start is less important than starting. Fears may bubble up and unconsciously subvert your beginning. You ask yourself, "What if I'm terrible? What if I fail? What if I ruin it and waste all these materials?" Here is my wisdom to you: Please fail! Please mess up. Please waste some materials as you learn. Then you'll grow and get better at your craft.

Before you start any project, it helps to warm up, to stretch your muscles—you need to get in the groove.

As I begin to paint, I usually get out a brush and ink. I will put the brush down and start moving it around—not to make a masterpiece, but to align myself with the slippery, fluid language of the ink. You can do this when quilting by stitching some loops onto scraps. In this way, you tap into yourself and get in the rhythm.

1 JUST START 13

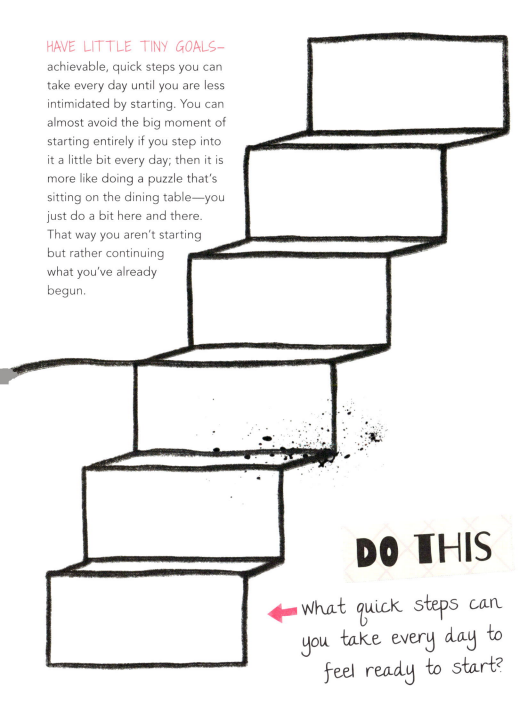

HAVE LITTLE TINY GOALS— achievable, quick steps you can take every day until you are less intimidated by starting. You can almost avoid the big moment of starting entirely if you step into it a little bit every day; then it is more like doing a puzzle that's sitting on the dining table—you just do a bit here and there. That way you aren't starting but rather continuing what you've already begun.

DO THIS

← What quick steps can you take every day to feel ready to start?

Visualize yourself and your process.
Can you see any obstacles?
If so, visualize a solution.

Make a list of obstacles below.

How will you get started?
Write out your steps on this road map.

What are your goals for your project?

Write your goals below on the sticky notes.

USE THE NEXT PAGE TO MAKE A MIND MAP. Start filling in the bubbles about beginning. This visual form of intuitive note-taking is something between drawing and sensing—it gives you a way to spill ideas onto the page. This is a soul diagram. It will help you navigate and understand your held beliefs about starting. Maybe you are trepidatious, cautious, or afraid, or maybe you are full of unbridled passion and bursting at the seams, or both!

1 JUST START 17

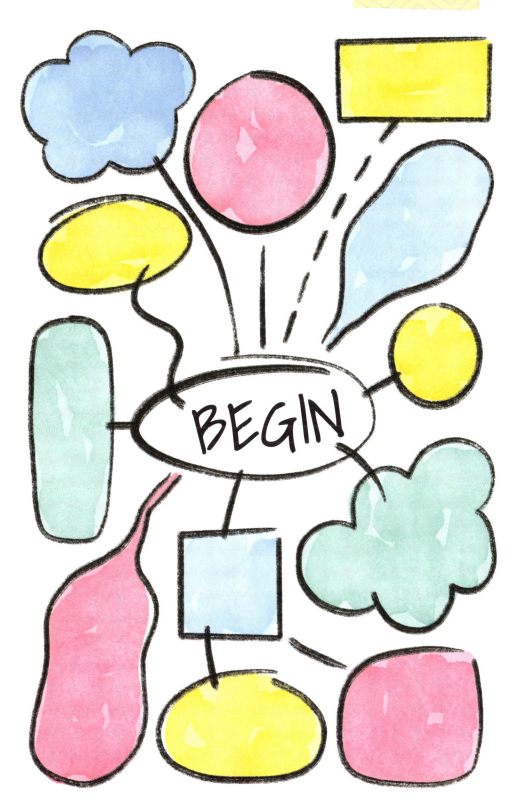

SPARK 2
CREATE THE SPACE

You need a space, big or small, in which to be creative.

Having a good workspace cements you to your dreams. The creative space is a launchpad, refuge, retreat, temple, labyrinth, and safety net. It gives you a sense of purpose. If you believe in your dream enough to make a spot for it in your life, then you're more likely to pursue your passion and hear the Spark when it calls. Not everyone has space for a private art studio or even an unused table, so be gentle with yourself as you are also creative with your space constraints. For example, creative space doesn't have to be a social media fantasy with perfect lighting and abundant houseplants. Work with what you have.

CONSIDER YOUR NEEDS AND REQUIREMENTS

Do you keep your space messy or tidy, organized or chaotic? Do you need lots of cabinets, drawers, boxes, or bins?

Do you need fresh air from an open window? Special ventilation for toxic materials?

Do you like to work on the floor? On a desk? At an easel? Standing up?

2 CREATE THE SPACE — 19

Make a list of your needs and requirements.

> "START WHERE YOU ARE." —ARTHUR ASHE

WHAT ELSE DO YOU NEED?

A computer?
A sewing machine?
A pottery wheel? A sink?

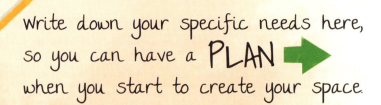

Write down your specific needs here, so you can have a PLAN ➡ when you start to create your space.

2 CREATE THE SPACE

Now sketch out your floor plan here. Add everything you think you need to be creative.

SPARK 3
TAKE A CLASS

MANY CREATIVES SUFFER FROM IMPOSTER SYNDROME; THEY WANT TO EXPLORE THEIR ART FORM AND EXPRESS THEMSELVES, YET FEEL LIKE THEY ARE FAKING. Formal training instills in you a sense of confidence. Confidence comes from gaining fluency. Classes will help you feel comfortable exploring your creativity. When you start something new, you are not expected to be good. You just need to have an open heart and be gentle with yourself as you learn. Stay in what Zen Buddhist teacher Shunryu Suzuki called your *beginner's mind*; *have an attitude of openness and lack of preconceptions* as you begin.

Ask lots of questions—and not just of the teacher. Ask your fellow students about what works for them: which local stores sell the best materials, which online retailers and suppliers they like. Your fellow students may teach you as much as your teacher. They will be supercharged and excited just like you. The kindred spirits you meet in your classes will give you a way of connecting to your new craft. Sharing people's stories while learning a new craft feels wonderful.

What classes and programs are available at schools in your area?

What local shops and studios are options for you?

Search online for classes in your area of interest; what are the possibilities?

What free tutorials are available for you on YouTube?

Who do you follow on social media that has great tutorials?

THE BIG BOOK OF LITTLE SPARKS CREATIVITY JOURNAL

WHAT DO YOU WANT TO LEARN?
MAKE YOUR LIST HERE.

SPARK 4

NEGATIVE SELF-TALK

<u>Life generally tampers with creativity because being a grown-up requires a great deal of organization and management.</u>

While being a grown-up and tending to responsibilities is necessary, it often comes at the expense of the messier and certainly harder-to-define urges of the human heart. One of those urges is the desire to create something—not for any specific reason, not for financial gain, not for ego gratification, but just because it feels good.

Negative self-talk is the opposite of the Spark. It is the voice that tells you that your urge to follow your creative dream is implausible or silly. But you can hush it up.

DO THIS

WHEN YOU FEEL YOUR INNER CRITIC RISING, NOTICE HER. GIVE HER A FUN NICKNAME!

The shift in awareness can be part of the cure and help you see your own thought patterns more clearly. You can then begin to poke holes in her presence by asking what benefit the negative self-talk provides you. Does it keep you small? Safe? Stuck? What is your net benefit from not stepping into the fullness of yourself.

THE BIG BOOK OF LITTLE SPARKS CREATIVITY JOURNAL

4 NEGATIVE SELF-TALK

REPLACE NEGATIVE SELF-TALK WITH EVEN THE BRIEFEST MANTRAS OR AFFIRMATIONS. Write a list here of the things that feel good to you when a friend or spouse says them to you. Let that positive and affirming voice become your inner angel, your inner voice. Next, write five things you absolutely love about yourself. Become your own loving voice.

SPARK 5

TIME

It is a fact of modern life that we are busy.

Cultivating a creative life will require some thoughtful shuffling of things to make room for it. Be aware of your own rhythms as you establish a creative practice so you can take the path of least resistance (which is always the right path).

DO THIS >>

What is your best time of day?

When do you feel most creative?

Have the most energy?

When are you sluggish, tired, or drained?

What times of day are more neutral for you?

26 THE BIG BOOK OF LITTLE SPARKS CREATIVITY JOURNAL

5 TIME 27

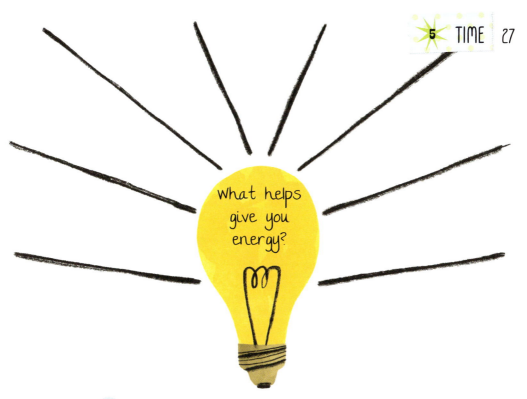

what helps give you energy?

You may not realize how much time you spend doing stuff you don't really have to do—such as reading your social media feeds, watching TV, or ruminating about that colleague at work.

What behaviors or patterns could you let go of to find more time for your passion?

WHEN CAN YOU SCHEDULE YOUR CREATIVE TIME?

Put it on the calendar. Set an alarm on your phone. Be prepared—have everything you need so you can dive right in.

SPARK 6
MAKE A HUGE MESS
Life is filled with opportunities.

If you are worried about getting dirty or making a mess, either metaphorically or for real, then you will be limited in your possibilities.

You know you are on the right track if you are making a mess of something. You have to fall on your face sometimes. Who is your life for? Is it a big performance that you have rigged up with hidden strings and edited with Instagram-style filters to make you seem beautiful and perfect all the time? I did that for a long time. The years I Photoshopped my life into perfection and managed my image for some perceived gaze were some of the least creative of my life.

DO THIS

TODAY, MAKE A MESS. Take off the Photoshopped filters you wear over your life. Sit down with the intention of making a mess, of making something you may or may not show anyone. Do a drawing with coffee on paper. Scribble all over this page with markers or pen. Stack some rocks. Sew some paper or packaging. Let yourself make a mess.

Write down a few sandy, gritty details of your life.

28 THE BIG BOOK OF LITTLE SPARKS CREATIVITY JOURNAL

WRITE DOWN THREE SELF-LIMITING BELIEFS YOU ARE AFRAID MAY BUBBLE UP AS YOU'RE GOING ABOUT YOUR CREATIVE LIFE. Honor them as beautiful, tender parts of yourself. Know that you are not perfect and that no one is. Know that the messiness that is your humanness connects you to others. The more able you are to share your truth in your creativity, the more whole you will become, and the more people can connect to your story.

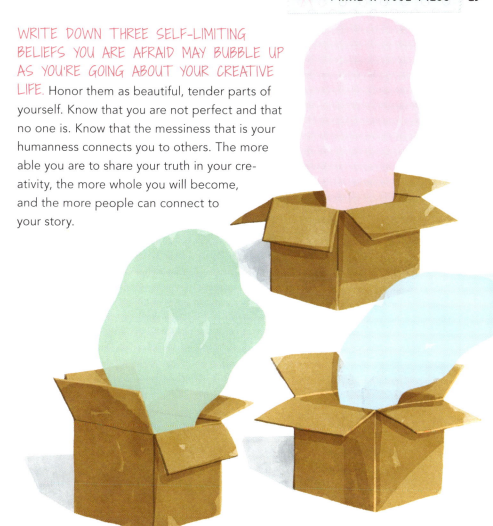

WRITE DOWN ONE EMBARRASSING BUT COMPLETELY TRUE FACT ABOUT YOURSELF—A JUICY DETAIL ABOUT YOU THAT MOST DON'T KNOW BUT YOU TAKE REAL DELIGHT IN. BE HER! We are complex unicorns; we can't move bravely forward if we're constantly afraid to show our realness through vulnerability and self-acceptance.

SPARK 7

PERMISSION

First, my creative parents said yes to my creativity, even as a baby.

My first real art teacher was Dicki Arn. Starting in kindergarten, she held my Spark in her palms and blew gently on my tiny flame all the way until sixth grade. In my heart, I know she is the reason my whole life has unfolded as it has.

Eventually, I met Anne Arrasmith, an artist and visionary working in downtown Birmingham, Alabama, at a studio she created called Space One Eleven. Her teaching style was radical—she didn't teach anything. She just said to her students, "Come on in, y'all. Now, let's get to work!" She trusted us to know what we wanted to make.

> "THE BEST TEACHERS ARE THOSE WHO SHOW YOU WHERE TO LOOK, BUT DON'T TELL YOU WHAT TO SEE."
>
> ALEXANDRA K. TRENFOR

She didn't give us assignments, lectures, or instructions. She gave us possibility and permission.

It is important to remember and be mindful of the blessings and resources in our lives that allow us freedom—open doors, yesses, possibility.

DO THIS GO FIND PEOPLE WHO SHARE YOUR PASSIONS OR INTERESTS AND HANG OUT, GET A COFFEE, AND CHAT. When we feel supported and connected, it connects us more deeply to our path.

INTERVIEW YOUR CREATIVE FRIENDS AND CRAFTY ROLE MODELS. Some people are book people and some people are people people. Which type are you? Do you want to do online searches or spend time in the library to help you navigate in your quest for examples of a creative role model? Or, do you prefer to chat, call up a friend or acquaintance you know to be a creative person living a creative life, and ask if you can buy her a coffee?

PICK HER BRAIN ABOUT HER CREATIVE LIFE.

What WORKS for her?

What doesn't?

Any helpful tips, hints, or tricks?

Ask tons of questions, and most especially the questions you are afraid, nervous, or too embarrassed to ask.

COUNT YOUR BLESSINGS: WHAT ARE THE BLESSINGS IN YOUR LIFE THAT ENABLE YOUR CREATIVITY? Resources? Experiences? I hope you need extra paper for this! I hope you need a whole journal but start right here, right now.

7 PERMISSION 33

Who are your open doors? Teachers? Friends? Write down who enables your passion and creativity, who has given you permission.

SPARK 8

PROCESS

In your creative life, you will find that you have your own process.

It is as unique as you are. And most likely, at least half of it will be what my brother calls "gettin' ready to get ready," the nonsense we do that keeps us busy and makes us feel productive. But what feels productive doesn't necessarily move you toward your goal.

Over time you'll begin to see patterns in your process. You'll develop your own methods and style. Ease into the work. The work is what you're after. It is the jewel of the journey—not the objects you create, but the act of creating.

Don't get discouraged. Be patient with the process. Enjoy the process free from chasing expectations. Be gentle as you find your voice and your wings.

IDENTIFY WHAT YOU KNOW ABOUT YOUR PERSONALITY. WHAT DO YOU ALREADY KNOW ABOUT YOUR PROCESS?

IS YOUR WORK USUALLY

SLOW AND STEADY ·· OR ·· **PANTS ON FIRE?**

DO YOU LIKE TO DO EVERYTHING
ALONE •• OR DO YOU PREFER TO JOIN WITH •• A FRIEND?

HOW WILL YOUR PREFERENCE AFFECT YOUR PROCESS?

HOW CAN YOU OVERCOME PROCRASTINATION?

HOW CAN YOU RECOGNIZE BUSY-WORK AND MOVE BEYOND IT?

HOW DO YOU OVERCOME BOREDOM?

HOW DO YOU HANDLE DEADLINES? Do you wait until just before a deadline and work nonstop until it's finished, or do you plan the project into manageable increments and are diligent over the course of months to achieve that same end?

WORK NONSTOP •• INCREMENTS

SPARK 9

GRACE

<u>Grace comes from not only being filled with purposefulness and spirit as we work but also enjoying the moment and being present with the process.</u>

Grace is the hinge between effort and effortless.

Sanskrit gives us an incredible term for this moment of balancing our own strength while also being relaxed or full of ease in yoga practice – *Sthira Sukham Asanam*

Too much effort and we are straining and forcing, too little and we are lazy. Grace offers gentleness and a lightness to our work.

A wise woman in Big Sur, California, Jan McCool, helped me understand this. I told her that I was afraid to design my first line of fabric (and write my first book) because everyone I spoke to said it was hard when they did it. She said, "THAT'S THEIR STORY—THEIR EXPERIENCE: EACH TIME SOMEONE TELLS YOU THEIR STORY, YOU PUT IT ON AND WEAR IT LIKE A COAT. MANY OF THOSE COATS DON'T FIT YOU AND YET YOU ARE WEARING THEM. WHY ARE YOU WEARING EVERYONE ELSE'S COAT? TAKE OFF THEIR COATS. GIVE THEM BACK. WHAT DOES YOUR COAT LOOK LIKE? YOUR STORY IS YOURS. IT MAY BE COMPLETELY DIFFERENT FROM THEIRS. YOUR STORY MAY BE THAT WRITING A BOOK IS EASY AND DESIGNING YOUR FABRIC IS EASY."

GUESS WHAT? She was right. If you step into that place of grace, you act in a way that seeks balance. I now consciously choose to not be stressed.

DO THIS

What coats did your parents give you? Or your friends? Teachers?

Are you still wearing their stories instead of your own?

If you find that you are wearing a bunch of other people's coats, give them back. Sit in a quiet place alone and close your eyes.

Picture the people who shared their stories with you. Thank them for sharing their experiences with you. Tell them that you no longer need their stories. **VISUALIZE HANDING THEIR COATS BACK TO THEM.**

WRITE DOWN, IN DETAIL, WHAT YOUR OWN UNIQUE COAT LOOKS LIKE. What experiences is it made of?

Write intentions to fill your process with grace or whatever it is that you want for yourself.

SPARK 10
BREAK YOUR OWN RULES

<u>Cultivating a creative life means thinking and acting in new ways so you can be open to the possibilities around you.</u>

You must disrupt your normal patterns so you can see the world with new eyes. Be disruptive of your creative process and your life, and you will find a wellspring of riches and freedom. Step outside the normal. Be curious. Today and while you are reading this journal, do lots of unexpected things. Surprise yourself. Break your own rules. Leave the trail behind. Bypass your patterns and routines.

DO THIS

WRITE DOWN BEHAVIOR PATTERNS THAT WERE CODED OR UPLOADED INTO YOU THAT AREN'T EVEN YOURS. Do you have behavioral expectations from relationships or responsibilities? Examine your default settings or even recent uploads to the hard drive of *you* that feel constricting or habitual. List ways you can reclaim space for acting in intuitive and responsive ways to each moment as it rises to meet you.

DO YOU ALWAYS BUY THE SAME VEGGIES AT THE GROCERY STORE? Go buy an eggplant or something in the store you have never even heard of or seen before.

TAKE A WALK WITH YOUR EYES CLOSED. Just try it. Try to walk down your street with a friend (to keep you safe), with your eyes closed.

FOR ONE DAY–ALL DAY–WRITE AND DRAW ONLY WITH YOUR NON-DOMINANT HAND.

Do you have an absolute favorite quote? Grab a pencil and write it directly on your wall so you can see it every day. Draw on your walls. Break a simple rule.

10 BREAK YOUR OWN RULES

FAVORITE QUOTE

SPARK 11

JAR OF MARKERS

No matter if your creative passion is playing guitar or glassblowing, you need several jars on your dining table

(or some other table that you sit at regularly)—one for markers, one for colored pencils, and one for plain yellow pencils and scissors. No matter what your creative fantasy is, you need ready access to writing, doodling, planning, and sketching tools. Creativity can strike at any moment, and you want to be ready for it when it does. The pens and pencils, always there, will quietly call to you, gently reminding you to listen to the call of your heart.

DO THIS WHAT OTHER INSPIRING TOOLS CAN BE A METAPHORICAL REMINDER FOR YOUR CREATIVE LIFE?

What **ARTFUL MATERIALS** can you set in the middle of your table? Maybe you could place a jar of antique whisks on your kitchen counter? How about a bowl full of guitar picks on your coffee table?

We all need reminders. What are some other ways to remind yourself to listen to the little spark today? Write yourself a Post-it note and put it on the bathroom mirror:

I WILL TAKE ONE RISK.

I WILL MAKE A MESS.

I WILL MAKE A CAKE.

I WILL TRY SOMETHING NEW.

I WILL FAIL AT SOMETHING.

MAKE A GOAL FOR YOURSELF EVERY WEEK

on a Post-it note, or write it directly on the wall. You can always paint over it. List 5 goals.

1. _____
2. _____
3. _____
4. _____
5. _____

THINK ABOUT HAVING AN EMBLEM FOR YOUR PASSION AND CREATE A LITTLE COLLECTION, SHRINE, OR ALTAR OF OBJECTS TO VISUALLY REPRESENT YOUR SPARK. Whatever inspires you, look at it every day. We all need reminders.

SPARK 12
GO WINDOW SHOPPING
Stores are the new galleries.

I am curious about the pageantry of this beautiful life—not just the beauty of the natural world (which inspires me daily) but also the pageantry of what we humans do here, the stuff that we make, sell, and buy. I have always been a huge fan of package design and international grocery stores. I love seeing the cultural differences in packaging and colors, the psychology of commerce.

You are surrounded by a tapestry of riches every day. See it. Be curious about the colors, the patterns, and the design of all of it. It will help you expand your thinking and engage with your senses in a different way. Being creative means wandering through your life like an openhearted warrior, paying attention to the world around you. It means seeing with your senses, feeling your way through the world, and finding meaning in what you see.

> CREATIVITY ISN'T SOMETHING YOU DO; IT IS WHO YOU ARE.

DO THIS TODAY, GO SHOPPING!

Go to the mall. Go to Anthropologie, Urban Outfitters, Nordstrom, Target, or Trader Joe's. Look around. Open your eyes to the giant creative engine that is using every resource it can to creatively sell you stuff. Go look at mannequins, displays, signage, advertising, and wall treatments. Look at the way merchandising tells a story that draws you in. Notice how the story of the brand is revealed through imagery, colors, textures, text, and graphics. REALLY LOOK AND BE INSPIRED.

12 GO WINDOW SHOPPING

WHAT CAPTIVATES YOUR IMAGINATION?

WHAT INSPIRES YOU?

GO TO AN INTERNATIONAL MARKET: AN INDIAN SPICE SHOP, A JAPANESE GROCERY STORE, OR A MEXICAN MARKET. Look at how different cultures approach package design. Look at how the natural world shows up in markets from different countries.

what did you see?

GO TO LOCAL PLACES

such as the farmers' markets, small boutiques, and cafés. Investigate the vernacular style of your town.

What does it say?

THIS IS AN EXERCISE IN SEEING CREATIVELY AND SEEING CREATIVITY.

If you can see it, you know it better, and it can inform your spirit and your practice. Being a creative person means way more than making cool stuff. It is a way of being in the world.

SPARK 13

GET IN YOUR BODY

Studies reveal improved creative thinking after aerobic exercise.

The mind can be so noisy. It is more than endorphins and blood flow—it is space. Getting into your body through exercise creates stillness in your mind.

Meditation is another way to find some quiet space. For creativity, it is important to turn off the incessant chatter of your mind and to bypass the intellect, to create a fresh place inside.

Creativity comes from innocence, openness, curiosity, and playfulness. You can bypass your intellect (and all its limitations) by actually physically moving it aside with exercise. Get to the business of tending to your soul.

DO THIS TODAY, IF YOUR BODY ALLOWS, TAKE A HIKE, A FAST WALK, A RUN, A YOGA CLASS, A SPIN CLASS, OR AN AEROBICS CLASS. Work hard. Breathe deeply. Lose your mind. Just be in the moment. I often have to write or take notes after I exercise because ideas come to me when I make space for myself. How did you feel after your exercise? What ideas came to you during your active time? **Fill in the spaces in the forest illustration with your answers.**

GO OUTSIDE! IF YOUR BODY DOESN'T ALLOW FOR MUCH MOVEMENT, SITTING CONTEMPLATIVELY IN NATURE IS AN INCREDIBLE PRACTICE FOR CLEARING THE STALENESS FROM THE MIND. Breathe the air. Feel it in your body. Notice the smells of your street—the natural world—explore the textures, sounds, and smells. Let them fill your mind, heart, and senses. Nature is spring cleaning for the soul! It is one of my main sources of inspiration and grounding. In Japan, people practice "forest bathing," or *shinrin-yoku*. *Shinrin* in Japanese means "forest," and *yoku* means "bath." *Shinrin-yoku* refers to bathing in the forest atmosphere, or taking in the forest through our senses. Numerous studies show the health benefits of this nature practice on a cellular level.

TOUCH A TREE.
COLLECT LEAVES OR BARK TO BRING HOME WITH YOU AS A REMINDER.

WHAT SMELLS DID YOU NOTICE?

WHAT SOUNDS DID YOU HEAR?

WHAT TEXTURES DID YOU SEE AND FEEL?

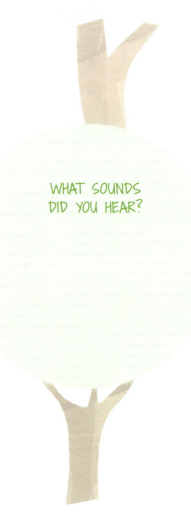

13 GET IN YOUR BODY 53

WHAT INSPIRATION
DID YOU GET?

WHAT DID YOU NOTICE
ABOUT YOURSELF AS
YOU WERE OUTSIDE?

WHAT CAN YOU
CULTIVATE AS A
NATURE PRACTICE?

**DOODLE YOUR
ANSWERS AROUND
THESE PAGES.**

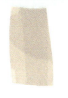

SPARK 14
INNER-KID CARE

You need look no further than the bright, shining, creative kid you used to be to find the source of your creativity.

REMEMBERING THE SPARK

See that kiddo with all that passion? All those ideas and dreams? That's you. See yourself as that child. Be as gentle with yourself as you would be with that young person.

Tape a picture of yourself as a child here, from the same time as your memories. He/she/they still lives inside you. He/she/they is your inner kid.

HERE IS WHAT MY SPARK LOOKED LIKE WHEN I WAS YOUNG:

WHAT HAPPENED TO THE SPARK?

THIS SPARK IS A REFLECTIVE MEDITATION. Give yourself some quiet time. You may read the prompt aloud and record it on your phone, then play it during your meditation. Get comfortable and breathe. Ask yourself to remember what happened to that Spark. Where did it go? When did you stop listening? How old were you? What got in the way? Did someone or something take it away or dim its light? Did you become embarrassed of your joy, passion, or talent? Did someone tell you that you could never make any money and you should find a different path? Did people tell you that you weren't good at it? Did you believe them? Did you feel you weren't good enough? Be there. See the details. It may be uncomfortable but stay with it. Then, come back into the present moment, into your body. Open your eyes. Most likely, tears will coat your eyelashes as they coat mine as I write these words because many of us carry so many feelings of inadequacy, fear, vulnerability, shame, or pain. Life has affected the little Spark for each and every one of us, even professional artists.

WRITE DOWN WHAT YOU UNCOVERED HERE:

You are probably feeling something now. It may feel tender or fragile, painful, or joyful. Write it down.

Begin to release the story that was written over your Spark, the story that was inscribed into your heart. Let it go. Cry if you need to. Some of the emotion you may have just unearthed is called shame. Shame comes from feeling fundamentally inadequate, from feeling flawed or not good enough.

If you bring your shame into the light, it can't lurk and haunt you from within. Shame is a powerful emotion. It seeks to remain hidden. It protects itself so you can't find it. But the moment you become aware of it nestling in the softest and most private inner folds of your heart is the moment you begin to lessen its power over you. It begins to crawl away. It skulks off.

WRITE DOWN ALL OF IT HERE. Bringing it into the light will help you move on and dive more deeply into your creative practice. That feeling might always be there to some extent, but once you name it and call it out, you have power over it, instead of the other way around.

REPLACE EACH OF THOSE NEGATIVE MESSAGES YOU WROTE WITH THE OPPOSITE.

If you wrote, "I am clumsy," change it to "I am graceful."

"I can't make any money being creative" becomes "I have a thriving business based on my creativity."

Now, grab a huge, fat Sharpie marker and cross out those negative messages!

TAKE SOME TIME TO PROCESS WHAT YOU HAVE LEARNED ABOUT YOURSELF. KEEP THIS WORKBOOK OR A JOURNAL WITH YOU BECAUSE YOU MAY HAVE MORE THOUGHTS YOU WANT TO WRITE DOWN. GOOD WORK.

14 INNER-KID CARE 57

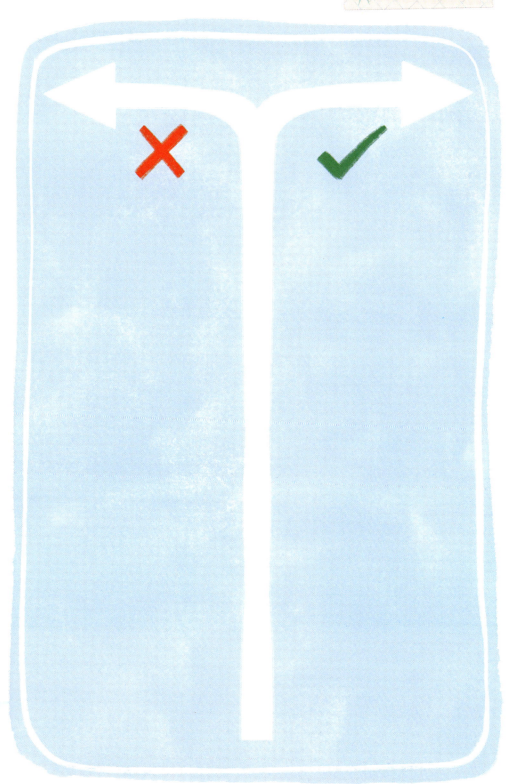

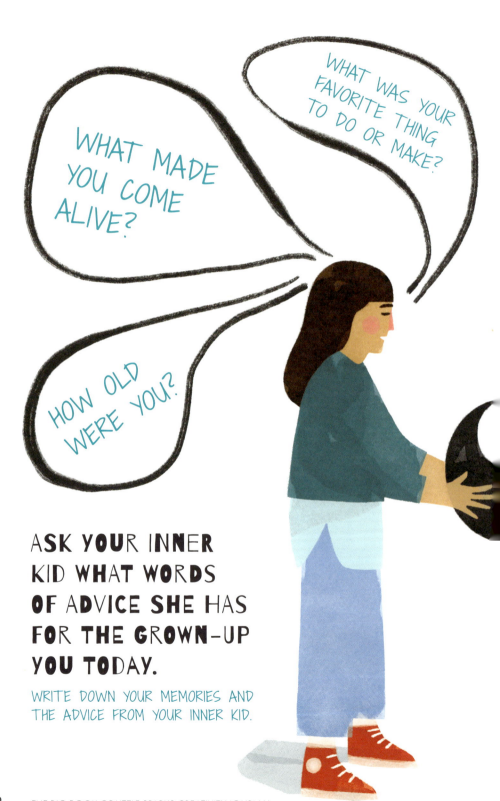

When did you stop listening?

How old were you?

What got in the way?

14 INNER-KID CARE

Did you become embarrassed of your joy, passion, or talent?

Did people tell you that you weren't good at it?

SPARK 15

DOUBT

one of the most important ways we can overcome self-doubt is to make peace with it.

BEFRIEND YOUR DOUBT. Notice when it shows up. Gently honor it like an old friend. Noticing when doubt is popping up is halfway to resolving it within you. Acknowledge the part of yourself that doesn't quite believe you can do it. Write affirmative responses and logical answers to the questions your doubt brings up.

"DOUBT KILLS MORE DREAMS THAN FAILURE EVER WILL."
—ANONYMOUS

FOUR WAYS TO REMOVE DOUBT

RITUALS

Use ritual to honor the transition into your creative activity. A ritual can be a simple thing we use as a tool to step into a more personal, internal space. It may be dark chocolate. It may be a moment of gratitude for the blessings of today. It may be a simple prayer in which you ask for strength and courage and that you work to your highest and best good. Maybe you say, "Today I will make a mess, play, and have fun." I burn sage (smudge) before I work (a Native American ritual), to clear the energy and start fresh. What's your ritual?

MUSIC

Since I was about fourteen years old, anytime I have started painting or working in my studio, I have put on pianist George Winston's *December* album. Every time. It is the thread that runs through my creative life. It grounds and centers me. Because I have been using it as a tool to enter my creative space for many years, it keeps me in touch with the girl who dreamed really big in her studio. It reminds me that the reason I make things is because of that girl—that girl in me who believes in herself so much. The girl who didn't think "no" was an option. I am still that girl. I get to her with the help of George Winston's somber, lyrical piano music. And when I am in the flow, I turn off George and get out my playlist and dance and sing like a kid. What is your music?

AFFIRMATIONS

Affirmations are a great way to stay present and grounded (and away from self-doubt).

I AM BEAUTIFUL · I AM TALENTED · I AM SMART · I AM CREATIVE · I AM KIND · I AM GENEROUS · I CAN DO ANYTHING. And my favorite: I AM ENOUGH. Get into the habit of saying affirmations to yourself daily or as needed. Be sure to choose affirmations that you actually believe about yourself.

TALISMANS

A talisman is an object believed to contain certain magical properties that may provide good luck or fortune. Talismans provide as much help to us as we believe they do—all in the name of good fortune and protection. Do you have a feel-good object? A special object or piece of jewelry that can be used to boost confidence, clarity, love—anything? It will help you get in the flow, like an external boost of confidence and intention.

DO THIS write your affirmations.

I AM

What will be your ritual or talisman for your creative practice?

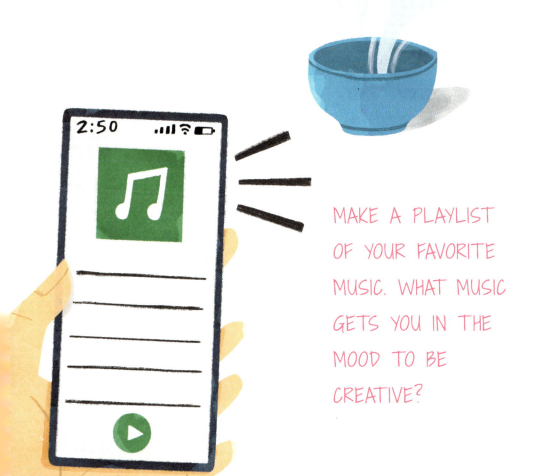

MAKE A PLAYLIST OF YOUR FAVORITE MUSIC. WHAT MUSIC GETS YOU IN THE MOOD TO BE CREATIVE?

SPARK 16

HAVE A SECRET

Creativity generally yields something that we share with others—a piece of music, a piece of jewelry, a quilt, a painting, or a photo.

Creative people tend to want to share their work and yet tend to be shy about that sharing. Your own creative voice can get a bit clouded by all the other voices you hear from peers and teachers. It can become confusing and difficult to listen to your own voice.

Often when you talk about things and ideas, it fuels and connects you. But sometimes it diminishes the power of something special that you are hatching inside your heart or mind. Sometimes you need to sit with your secret treasure and let its embers warm you from the inside and just feel the glow.

There are times when you need to be alone with your own creativity and just sit with that private experience. Just be with the tiny Spark. Sit still and don't shout it out—just be. There is so much power in not talking about things. They become more real in your mind, more concrete, more personal.

WORK JUST FOR YOURSELF AND NOT FOR SOME EXTERNAL REWARD. THE REWARD IS INSIDE YOU.

16 HAVE A SECRET

DO THIS This lesson is a powerful one. Do something alone, just for you, by yourself. Do it today. It could be making something or writing or dancing alone under the full moon. See what you find. Honor your creative moment, whatever it looks like. And, then just percolate. Feel it. Don't tweet it, Instagram it, Facebook it, or blog about it. Don't tell your spouse or best friend. Don't tell your parents or children. Just be alone with it.

SPARK 17

INSPIRATION

In our modern world, we are bombarded daily with many varieties of images.

How you look at them helps you find the keepers, the good stuff you need to light your way. These are the fireflies.

When we step into a life of chasing the fireflies of inspiration, we are more able to get into a creative space. By doing this, we create a fluency between our so-called normal life and our creative life. Pretty soon, they begin to merge. Our life begins to shimmer, glow, sparkle, and radiate with creative energy.

INSPIRATION IS FUEL FOR THE LITTLE SPARK. It is the lamplighter, the flame maker, the firefly. It is the lighthouse. We cultivate it simply by being open to it. Be curious in your life. Always be ready to capture those fleeting ideas. Inspiration often surprises us when we least expect it. I'm often inspired by movies, animated cartoons, advertising campaigns, shapes or aspects of the natural world, and my family. Look for inspiration outside of your medium. If you're a quilter, look at art history or woodworking. If you're a dancer, look at poetry. Looking outside of your medium for inspiration gives you a fresh perspective and makes your work less self-referential.

SLOW DOWN, UNPLUG, AND DAYDREAM.

17 INSPIRATION

DO THIS

What inspires you?

What are you curious about?

How can you get more inspiration?

Where do you usually find your inspiration?

Who are your creative superheroes?

Who inspires you?

SPARK 18
THE PLEASURE PRINCIPLE

What makes you feel good?
Pleasure, pleasure, pleasure
the whole way through.

Children seek pleasure at every turn. They know how to play, how to have fun, or how to make room for themselves. They know what feels good. And so should you.

Your life is full and, no doubt, you have your hands full. But, unless you begin to uncover yourself from the bottom of the heaping, mountainous pile of your obligation and business, you might not get a crack of time to culminate your creative self.

That is why you need to get in touch again with what feels good, just for you. If you can begin to discover and uncover *your* desire, you can pursue the Spark.

BEGIN TO EXCAVATE THE STUFF THAT IS JUST YOURS—NOT FOR ANYONE ELSE OR BECAUSE OF ANYONE ELSE.

DO THIS

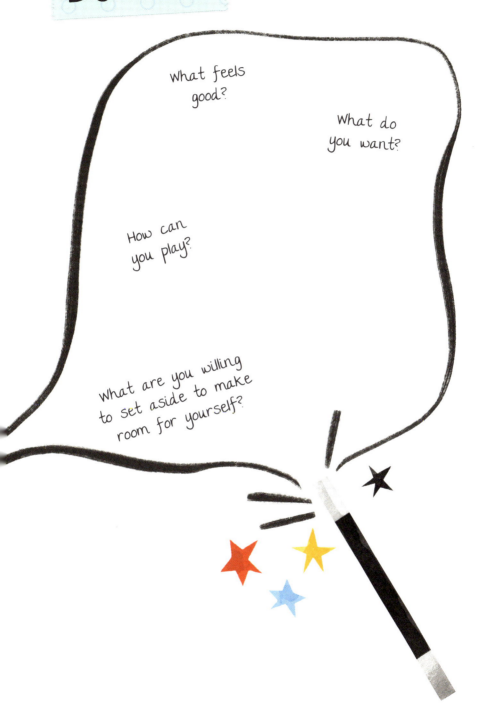

What feels good?

What do you want?

How can you play?

What are you willing to set aside to make room for yourself?

SPARK 19
MAKE A VISION BOARD

A vision board is simply a collage of images you pull from magazines and other places and paste to a board.

This exercise puts you directly in touch with your desires. It leaves you with a visual inventory of all the stuff that bubbles up from your unconscious mind and heart to illuminate your path and remind you of what you want. The boards can be as artistic or as simple as you want.

PUT YOUR BOARD IN A SPOT WHERE YOU CAN SEE IT EVERY DAY. The amazing thing about vision boards is that I have never made one that didn't come true. What you put on your board will show up in your life. It will be created in your life through your intention. You will manifest what is on your board.

DO THIS To make a vision board, tune in to your heart and soul. Sidestep your mind by banishing your inner critic, judge, and editor. You are only going to be listening to your desire. Not your desire for your partner, your children, your friends, or your family. Just your desire, for you. Repeat this exercise anytime you feel that you need a boost of direction or inspiration.

19 MAKE A VISION BOARD

MATERIALS

- Scissors
- Glue stick
- Foamcore board (or any other board) in any size you like (20″ × 30″ is a good size.)
- 6–10 magazines about varying topics that interest you
- Family photos or any scraps of materials that you want to add

As you are looking at magazines, don't **"SHOULD"** on yourself—no "I should pick this image" or "I should want that one."

NO CRITIQUING YOUR CHOICES OR URGES.

When you see something you like, rip it out. It is simple. If you have no idea why you are ripping out an image, rip it out anyway. Sometimes we aren't always aware of our own greatness or even what awaits us.

YOU AREN'T MAKING ART.

Remove your notions of how pretty your board will look, how perfect, and let it just be however it is.

So, for an hour, rip or cut out images. Then, for the next hour, paste them down.

SPARK 20
CREATE A MISSION STATEMENT

Your mission statement is one way to water your creative grass.

YOUR INTENTIONS, THOUGHTS, AND DESIRES WILL CARRY YOU ALONG.

In this Spark, we'll write a non-business "business" plan—a creative mission statement. But first, let's smash your fantasy. Whatever you think a "creative life" looks like, toss it out the window. Whatever you think your creative process looks like, chuck that one out the window, too. Let them go!

You'll need your dreams, your desires, and your intuitions to guide you on your path to a more creative life. What you won't need are your projections and fantasies of Photoshopped perfectionism, all tied up in a pretty bow and stylized like a cool magazine lifestyle shot. Smash those ideas to bits. They will just get in your way. You have to start with your feet on the earth, even as you reach for the stars.

Picture people you know who have found purpose, pleasure, passion, and quietude in their creativity. Picture in your mind your friends who water their grass. Close your eyes and picture yourself in your creative life. See as many details as you can. Be specific.

Start right here, right now, from your heart. Take a deep breath. Sit still in a quiet room.

FOCUS ON WHAT YOU REALLY WANT. This exercise can be done a few times until you feel like you are getting close to what you really want but still perhaps feel weird about verbalizing.

DO THIS

Use one word to describe what your unique creative path looks like.

Use one word to describe how it feels, or how you imagine it feels, to be on that creative path.

How about two words?

Write it as a sentence.

WRITE A MISSION STATEMENT.

Set your intentions right here on this page. Write it in the present tense and in first person. Be as specific as you can. Include details.

EXAMPLE

I am learning modern dance at a local dance studio. I feel competent and alive. I perform with the group on stage. I feel graceful in my skin. I feel content and peaceful. My whole life is transforming as I open up to my passion.

USE NICE PENMANSHIP AND WRITE YOUR STATEMENT ON A PRETTY PIECE OF PAPER. OR TYPE IT OUT ON THE COMPUTER IN A COOL FONT. PUT YOUR MISSION STATEMENT WHERE YOU CAN SEE IT EVERY DAY. IT WILL BE THERE TO GUIDE YOU.

Write out your mission statement on the next page to get you started.

 CREATE A MISSION STATEMENT 77

SPARK 21

FEAR

Fears will come. They always do.

Fear is a human emotion, common to all people, yet oftentimes driven by previous experiences. Fear is the boiler room in the basement of your creativity. The same logs of imagination that fuel the fire of your fears also fuel your creativity. Those wildly scary stories you tell yourself that give you anxiety attacks come from the same source (your imagination) that helps you create wildly imaginative works of art.

The creative act is the opposite of fear, because to create means to believe in the here and now. Being creative is an answer for right now. When you make something big or small, you become the answer to your fear. There are really only two emotions—love and fear. We slip between the two. Choose love.

CREATIVITY TAKES COURAGE. IT TAKES COURAGE TO BE WHO YOU ARE. It takes courage to step into the unknown, to dig around in your soul and see what you find, to follow your passion, to start something new, and to be vulnerable enough to fail repeatedly.

DREAM BIG. IF YOUR DREAMS DON'T SCARE YOU, THEY AREN'T BIG ENOUGH.

FAKE IT 'TIL YOU MAKE IT

In her June 2012 TED Talk, Amy Cuddy spoke about her research into body language. (Watch it on YouTube.) She offered what she called a "free, no-tech life hack" called "power posing." She spoke about the impact our body posture has on our success. Cuddy's research shows us that we can actually rewire our minds, simply by changing our posture.

She tells people: in a private place, stand tall in a pose with your hands on your hips for two minutes. Power pose before a meeting or class or whenever you need a confidence boost. The goal is to feel empowered—even if it's fake. As Cuddy said, "Fake it 'til you become it."

DO THIS

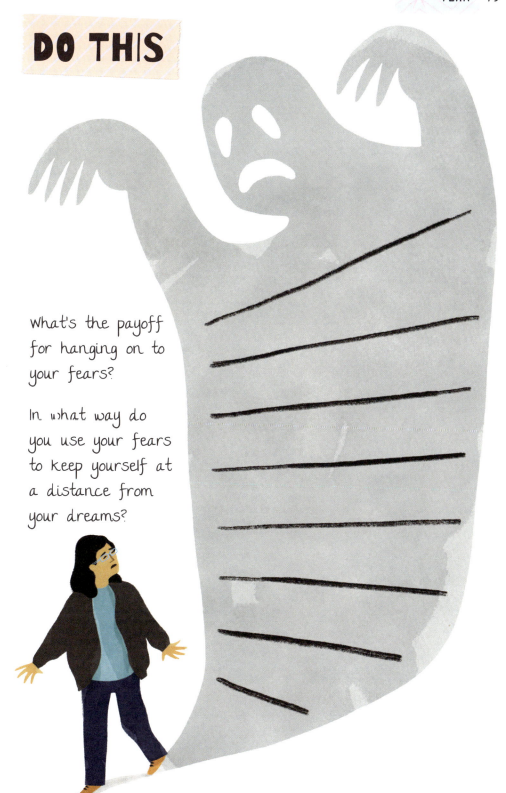

What's the payoff for hanging on to your fears?

In what way do you use your fears to keep yourself at a distance from your dreams?

PRACTICE YOUR POWER POSE.

How does it make you feel?

Do you use your fears as a Band-Aid to protect yourself from the pain of possibly not achieving your goals? Do you use it to also protect yourself from success?

FEAR

What are you afraid of about your creative path?

Write them below and then cross them off when you no longer carry these fears with you.

SPARK 22

FIND YOUR VOICE

Living as a creative person calls on you to be exactly who you are.

No matter what you do in your creative life, you will bring all of you to it. Creativity needs a subject. The subject of your creative life is you. You bring your senses, awareness, experience, and story with you.

As you figure out your preferences and desires, you will be cultivating what is called your creative *voice*. Your voice is a combination of your style, experience, work, and subject matter.

PEOPLE WILL FEEL YOUR JOY, LOVE, AND EXCITEMENT IN YOUR CREATIONS. THEY WILL ALSO FEEL YOUR PAIN, CONFUSION, STRUGGLE, AND FEAR.

The things you make speak for you in the world. The creative product, whether a poem or clay bowl, is infused with your spirit. Everything you create is a self-portrait. The richness you mine for your subject is your own psyche.

If you're lucky, you can shed the crap that spews from the ego—the stuff that keeps you safe, stuck, or living someone else's dream of your life. That stuff keeps you from yourself. Being comfortable in your own skin helps your creative process in huge ways.

SELF-ACCEPTANCE AND SELF-LOVE ALLOW YOU THE SAFETY NET YOU NEED TO EXPLORE AND EXPERIMENT.

DO THIS

In this exercise, you'll create some starting points for you to use in your self-expression. You'll make an inventory of the things that make you *you*. The answers are just for you. You'll see patterns in your answers as you uncover your true self.

What do you want to say?

What does it feel like to just be you, the complexity of you, the wholeness of you?

What does it feel like in your bones and skin? What makes you come alive?

What fires have you walked through that have made you who you are? These fires will light the path.

THE FOLLOWING IS A REFLECTIVE EXERCISE TO HELP YOU FIND YOUR VOICE. Just be with it. These answers are just for you. You don't need to do anything with them. If you are vulnerable enough, some of your life story may show up in your work. You might even use this list as source material for your creations—as a light to illuminate the path.

What are three of your most joyful experiences?

What was a painful experience?

What are ten things for which you are grateful?

What is the kindest thing someone ever said to you or about you?

22 FIND YOUR VOICE

What are your all-time favorite five movies, books, and songs?

What would you create if you knew no one would judge you (be specific)?

What is something you have never told anyone?

What makes you happier than anything else?

What is the best dream
you ever had in your life?

When do you feel
the most beautiful?

When do you feel
the most alive?

If you could choose
a superpower, what
would it be?

What makes you feel loved?

22 FIND YOUR VOICE 87

If you could live in any city or village on the earth for one month, where would it be?

When you were a kid, what was your favorite activity? Game? Place?

What form of service would you choose to help the world or give your time?

What would you grab if your house were on fire?

SPARK 23
REPETITION

We get better at anything we try to do by doing it over and over (and over and over).

There is only one way to achieve the fluency, freedom, and grace of the expert, and that is by doing. The reality of the creative life, no matter what form your creativity takes, is that you will have to work. To do it well you need to keep going, work hard, and try. We learn by coding the habit of creating into our body. Repetition is the key.

THERE IS ANOTHER NAME FOR REPETITION, AND THAT IS WORK.
To find success at anything, you're going to have to work hard. You have to show up for yourself through dedication and effort. This repetitive aspect of showing up for yourself can become boring or limiting, but is essential.

I highly recommend that when you sit down to throw a hundred bowls or sketch twenty self-portraits that you not go it alone. This depends on your learning style (take the quiz, page 8), but regardless, information is everywhere. If you aren't in a class or don't have a friend to ask, go online and watch a video.

THE BIG BOOK OF LITTLE SPARKS CREATIVITY JOURNAL

DO THIS

CREATE A NEW HABIT.

Write down your new habit and then fill in each day you act on it.

TODAY, MAKE A TIMELINE FOR WHAT YOU WANT TO CREATE.

This can be a calendar or even just a series of dates. This timeline can be achieved if you repeatedly show up for yourself and make your passion your priority.

What obstacles can you already anticipate when you plan ahead? How can you support yourself to avoid those obstacles?

ARE YOU A

LINEAR TYPE-A PERSON •• OR •• **COMPLETELY ORGANIC AND HATE DOING THINGS THE SAME WAY TWICE?**

Whatever your work style is, BE HONEST AND ACCOUNTABLE HERE so you can lend yourself a hand when you need a nudge to keep going.

YOU KNOW YOURSELF BETTER THAN ANYONE!

SPARK 24
SHINE YOUR LIGHT

Do you in some ways feel unworthy of the great beacon that lives inside your heart?

At the same time, how easy is it for you to help support your children, friends, or spouse to shine their light? Pretty easy to help someone else, isn't it?

YOU MAY NEED TO GET A BIT MORE COMFORTABLE PUTTING YOURSELF OUT THERE, BECAUSE YOU ARE PROBABLY GOING TO HAVE TO SHARE YOUR CREATIONS WITH THE WORLD. Hence, you've got to shine your light. It isn't arrogant, egocentric, or attention seeking to shine out from your heart. It is more like becoming a beacon. The more you reach inside for your passion and potential, the more other people will see and feel that in you. You then inspire them to their own light.

Don't diminish your glow for anyone else or for any reason—ever. Your passion belongs to you. No one can take it away.

So much of creativity has to do with something much greater than just making pretty things. You have to let go of the feeling that you don't deserve to be happy or that you could never have the freedom that you seek.

Being comfortable inside your skin is a life's work. It has its merits. Let's say you want to show your paintings in a gallery, or take your web design business to the next level with clients, or pitch your first book. You will need to practice confidence and allow yourself and others to see the light in your heart. You may as well start now.

 SHINE YOUR LIGHT

DO THIS

WHAT CAN YOU DO TO CELEBRATE YOURSELF?

Celebrate each step. Celebrate your small victories. Sparkle.

MAKE A LIST OF EXAMPLES of how you can treat yourself, today and this week, with the same kindness, gentleness, and love that you would show to your dear friend or to a child.

SPARK 25

MAKE A SOUL BOX

A SoulBox is a project I cooked up that lets you do a bit of soul archaeology and have fun while making a meaningful reminder of what is most important to you.

It will remind you of your passion. You can use it as a resource when you need it. It is a special place for gathering meaningful things, words, and ideas. Essentially, it is a decorated box, filled with messages, images, and treasures (found or made).

Your box might be filled with gratitude or affirmations. It might contain remnants from your past and your childhood dreams. You can write down each of your blessings from the Count Your Blessings exercise (page 32) on cut rectangles of card stock and use it as a blessings bank, adding more and more slips of paper until it is overflowing.

WHAT YOU NEED

1. Empty wooden cigar box (you can often get these at cigar or smoke shops); you can also use a tin, a shoe box, or any other box you have around

2. Materials from around your house: photos, trinkets, objects, or crafting items

3. Pretty art papers, decorative paper, or gold leaf to cover the inside or outside of the box

4. Card stock

5. Special crafty stuff that you have been holding on to for a long time and you aren't sure what to do with—you were saving it for this!

6. Natural materials from outside, such as seashells or branches (if you are so inclined)

7. Paste, glue, glue gun, Mod Podge (by Plaid), tape

8. Acrylic paints and brushes

9. Magazines to find images and words

10. Craft knife (such as X-ACTO) and/or scissors

25 MAKE A SOUL BOX

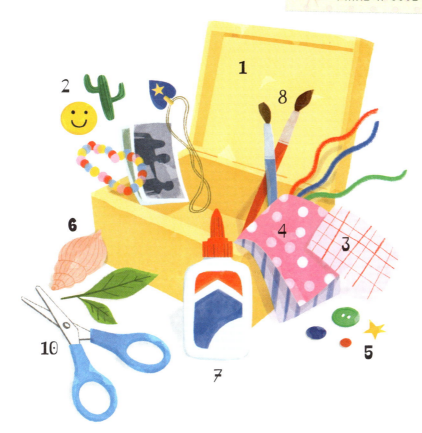

WHAT TO DO You may want to invite a few friends over when you do this so you can all make boxes, or maybe you want to work alone. Assemble your desired materials. Look at the treasures you have collected. Maybe you have a plan in your mind and you go for it, or maybe you just start doing things to your box and see where it takes you. As you are working, don't fret about whether it is perfect or even pretty. Just let it be playful and meaningful to you.

1 Decide how you want to treat the surface of the box. Maybe paint it like a sunset or the ocean or anything that reminds you of your soul's desire? Maybe cover it in paper? Use Mod Podge, matte medium, or paste to decoupage the decorative papers to the surfaces of your box. The outside and inside might be completely different. Let the box dry; then add any embellishments you want. After it is completely decorated, start filling it with treasures, pictures, words on cards—anything!

2 Place your box next to your bed or somewhere you can see it daily. Let it be a changing space—add to it; take things out. Have a conversation with yourself through your box.

SPARK 26

TAKE A DAY OFF

<u>There are books that tell you to be orderly and disciplined as you pursue your passion, to treat it like a job, to punch in on the time clock, to be diligent and earnest in your efforts—constant, consistent, patient.</u>

These books want you to sit around in the studio and wait until a butterfly flies into the room. Precisely because you have been in there waiting, you will be ready for it. It's sort of like fishing for magic—if you wait long enough, something wonderful will happen.

Then again, you could just take the day off—actually go fishing, connect with the natural world and your senses—and come back filled with inspiration and magic, ready to get to work. Personally, I'll go with the second option any day.

Sometimes, you've got to go find your soul on the road, or in a book, or at the beach. You've got to run away and do nothing.

YOU CAN'T FORCE YOUR CREATIVITY. YOU CAN'T STRONG-ARM YOUR INSPIRATION. I DO BELIEVE IN WAITING IT OUT.

DON'T GET ME WRONG. I ALSO BELIEVE IN WORKING.

I believe in working through the boredom, the obstacles, the writer's block. But there is a time and a place for everything. Sometimes you just have to run away. Sometimes you need time to recharge the battery. Sometimes you need to play hooky. Then, when you come back to your work you are so much more relaxed, and more often than not you have gotten past your roadblock and are able to see abundance, blessings, and inspiration all around you. This stuff is the source for the Spark. For me, inspiration lies in the world, everywhere—love, passion, family, relationship, connection, and kindness. This is what I use as raw material. I can't always get in touch with the source of my creativity when I'm cooped up in my cinder-block studio. I have to go into the world and jog my senses to find it. I have to ignite the flame by playing and looking and exploring the world.

DO THIS

What new experience can you find? Research it. Go find it. Travel to see it.

Where will you take yourself on a date? A museum, a concert, the bakery, the glassblowing demo, the poetry slam?

What expert will you watch pursuing his/her craft? You learn so much by watching subtle movements and seeing small technical tricks.

SPARK 27
SHARE YOUR WORK

TAKE IT TO THE STREET

One way to share your creations with the world is the traditional face-to-face sharing of the gallery show, the craft fair/farmers' market, or the concert. You might invite a few friends over to show them what you've been up to. These days, businesses want to feature local artisans, so talk to shop owners about featuring your wares. Approach a local coffee house or boutique about using its walls for a month.

WHEN YOU ARE READY TO SELL YOUR STUFF, THINK OF IT AS A LEMONADE STAND.

TAKE IT ONLINE

The other way to share your creations is online. There are more and more sites on the web that allow you to set up your very own online retail shop, such as Etsy. They are simple to use, and you don't need to have a separate website plus additional shopping cart functionality.

Another way to share is via social media. The amazingly vibrant modern craft movement happening around the world is borne aloft on the wings of Twitter, Instagram, TikTok, Facebook, Pinterest, blogs, and more. Social media allows you to share your process through photos, as well as keep all your friends in the loop. Blogging is a way to create a website and give voice to your process.

▶ YouTube: _____ 📷 Instagram: _____
♪ TikTok: _____ Ⓡ Reddit: _____
ⓕ Facebook: _____ ⓟ Pinterest: _____
🐦 Twitter: _____

THE BIG BOOK OF LITTLE SPARKS CREATIVITY JOURNAL

PRESENTATION IS EVERYTHING

Presentation is everything. Regardless of how you choose to share your work, this is the key. The clearer, more precise, and more intentional you are about your presentation, the better your viewer will be able to see your work.

You want to set the stage for the viewer. Beginning with the graphic design of your show announcement, you are telling a story about yourself and your process. People will see your love. They will see and appreciate your work that much more if you have filled the gallery with fragrant stargazer lilies and mopped the floor with eucalyptus oil. They might not even be aware of all the preparations, but it will help your work.

Whatever it is and however you choose, get out there and start sharing your work. Make your own lemonade stand!

WHATEVER THE TONE YOU ARE TRYING TO SET, SET IT FULLY. GO ALL THE WAY.

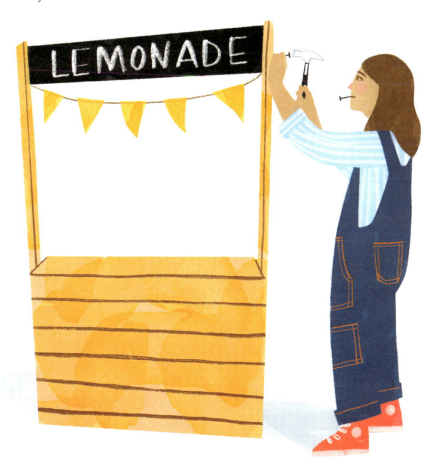

WHAT SITES OR PODCASTS INTEREST YOU?

Do you want to design your own site?

27 SHARE YOUR WORK

If you are a writer, what are your favorite online or print journals? Submit your work to them.

SPARK 28

GIVE IT AWAY

<u>Creativity is a way of being—a way of thinking, living, and expressing</u>.

IT ISN'T LIMITED TO ART OR EVEN TO SOMETHING WE MAKE. IT IS A WAY OF RELEASING THE CONTENTS OF THE HUMAN HEART. WE FIND LOVE; THEN WE GIVE IT ALL AWAY.

I have so many friends, mothers my age, who tell me they aren't creative, but they wish they were. They organize their families and their homes, and they fill up bento boxes with colorful, nutritious lunches every day. Often, they give their time to charities—organizing the gala or school auction. I look at them, mystified by their inability to see their own gifts, and say, "But you organized that entire auction, from top to bottom, and a hundred people, and all those gift baskets!" The light goes on when I say this. They can see that it is a very creative act.

We are often able to rise to our highest self if it is for someone else. Now that you are on your creative path, you might find that you have opportunities to use your expression to give back—to help others.

When you are in your creative process, you'll end up with a lot of things that you have made. It feels good to come full circle and let go of some of it. Go to a women's shelter and offer up your gifts. Donate your work to the school auction.

> "FIND LOVE, THEN GIVE IT ALL AWAY."
> CLEM SNIDE

Now that you have found your love, your creativity, your Spark, it may help to remember to give it away. Let the light shine out and touch other people. Using your gifts to help others is a nourishing experience. You'll get back way more than you'll give.

DO THIS

28 GIVE IT AWAY

In what ways are you already creative in your daily life?

How can you use the gifts of your spark to give?

What will you give and whom can you give your creations to?

Research local charitable foundations in an area of your interest.

SPARK 29

LEAVE IT ON THE FIELD

Leave it on the field. Make yourself proud. Give it your all. Do your best.

DON'T HOLD BACK, WAITING FOR SOME SPECIAL MOMENT TO SHINE YOUR BRIGHTEST.

Right now is when you should shine. Right now is when you step up into the fullness of your potential. Leave it on the field. Leave it in the dance, on the canvas, in the pie, in the clay, in the song. Know that you can and you will.

No matter what form your creativity takes, you have to let go of expectations and perfection. There is no such thing as perfection. There is only trying, doing your best, and leaving it all on the field. If you do your best, honor your journey, and love yourself along the way, then you will find the pot of gold at the end of your rainbow.

THE POT OF GOLD IS EVERYWHERE WHEN YOU GO WITH THE FLOW, SURRENDER TO THE PROCESS, STOP CONTROLLING, AND LET YOURSELF BE FILLED WITH JOY AND LOVE.

29 LEAVE IT ON THE FIELD 109

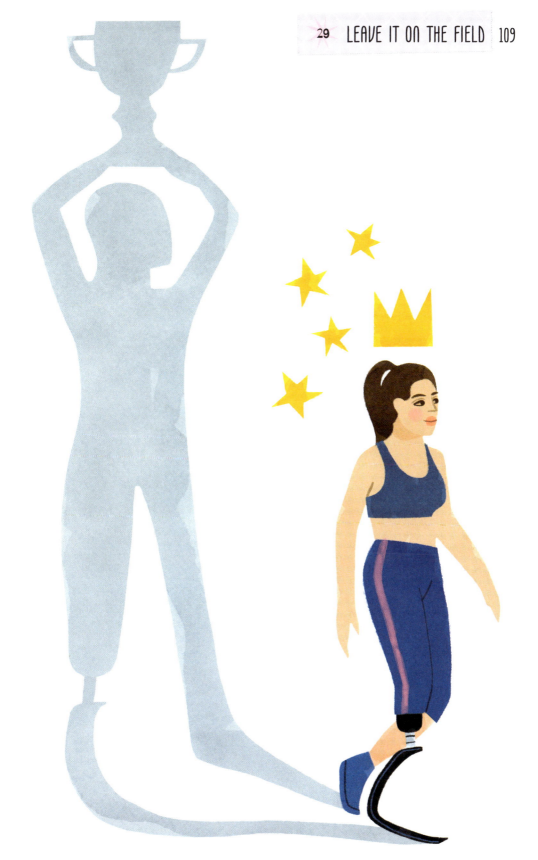

DO THIS

WHAT CAN YOU LET GO OF THAT IS HOLDING YOU BACK?

HOW ARE YOU A PERFECTIONIST?

WHY ARE YOU A PERFECTIONIST? EXAMINE WHAT HAPPENS IF YOU LET GO OF THAT CONTROL OF YOUR IMAGE AND YOUR SUCCESS.

29 LEAVE IT ON THE FIELD

WHAT WOULD IT FEEL LIKE
IF YOU FAILED PUBLICLY?

WHAT MIGHT IT FEEL
LIKE TO SUCCEED?

SPARK 30
BE YOUR OWN UNICORN

Be your own unicorn at all costs and at all times, instead of living up to expectations set for you by some invisible herd.

The hive mind may ask you to be normal and conform, even at the cost of your self-evolution or desires. Banish the urge to blend in. BEING YOUR OWN UNICORN MEANS YOU ARE BOTH THE WIND AND THE SAIL. You are propelled by an invisible force that you create. This doesn't mean to be weird or purposefully demonstrative in some outward way—you're welcome to do that if it feels good, but this is about listening to the pull of the creative life when it calls to you, even if you don't quite understand.

Trust the path. Use the force. Be available. Notice the world around you deeply. Being awake and aware of the nuanced complexity of this gorgeous human experience is the key to a creative life, as it allows you to sort through your feelings and inspirations on a moment-to-moment basis so you can decide what calls to you next.

LIVING A CREATIVE LIFE IS A PRACTICE.

 Notice the seasons, the changes in the natural world around you, the quality of light, and wind patterns.

DO THIS

 Notice the sunset and the smell after rain.

 Notice the well of sadness you may feel in your body.

 Notice when everything feels easy, joyful, or just right. Notice that joy and pain are often felt at once, commingling in the body.

 Notice that you cry at every commercial because living this life is so stunningly beautiful.

 Notice your anticipation of seeing someone you love after a long absence and even how fleeting it is when your time is over.

 Notice when you want to close your eyes and feel the sun on your face.

 Notice when you're called to make something simple for your home, like a bookshelf out of stacked pine lumber.

 Notice how making dinner with ripe tomatoes and basil grown in your backyard garden feels in alignment.

WRITE DOWN ALL THE THINGS YOU NOTICE AND RECORD HOW THE NOTICING FEELS IN YOUR BODY. Where in your body do you feel specific emotions and experiences? Begin to see and connect your outer and inner worlds.

All of that noticing is living life wide awake, and it will save you. It will help you soar.

It will lift you above the naysayers and the sleepwalking crowd. They made their choice.

MAKE YOUR OWN. BE YOUR OWN UNICORN.

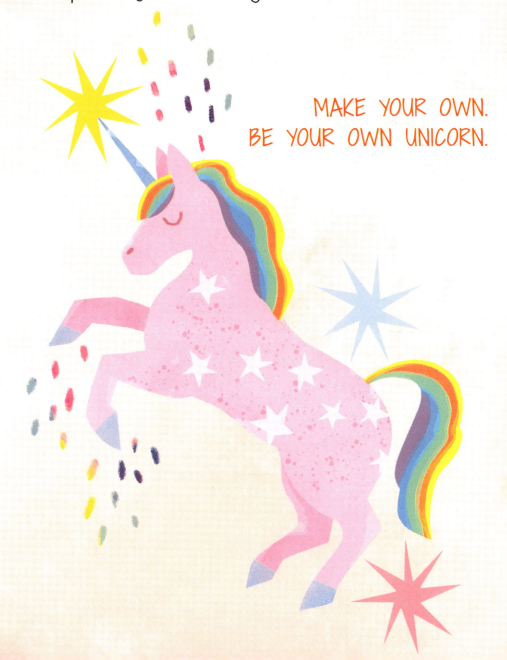

SPARK 31

DECENTER YOURSELF

<u>Every article you read on the internet about mindfulness urges you to be centered and grounded to cultivate a healthy psycho-emotional life.</u>

That is, of course, so true. When I urge you to decenter yourself, I'm referring to something a bit different. I'm talking about you being a fish in a fishbowl. The fish doesn't know it's in water; it just swims. Sometimes we need to jostle ourselves a bit to glimpse different viewpoints into ourselves. I want you to get outside your fishbowl and view yourself from multiple vantages. This Spark is a paradox to all of the others I've offered in this workbook. Each Spark I've offered so far places your lived experience at the center of the work of cultivating creative freedom. I have urged you to be present with yourself and excavate your soul to find the wisdom you have within you. In this paradox, I urge you to periodically shift from the *I–Me–My–Mine* understanding of your narrative to simply *Ours*. What happens when you come at your story from the place of the collective, the shared, or the communal?

In this process, you decenter yourself from the star, hero, or soloist of your story to one of many voices in the supporting choir around you. When you can shift from *I–Me–My–Mine* into being one of many, one of eight billion, you have the luxury of seeing your process and your experience as though you were outside of yourself. You can see yourself in scale. There's great liberation from clinging to every idea, creation, and attempt at making something. This awareness brings both levity and depth to the table and allows a sense of humor in your work.

31 DECENTER YOURSELF 117

DO THIS See your smallness as a tool of liberation. You are one drop of water in the river of humanity—one star among many.

> ZOOM WAY, WAY, WAY OUT. SEE YOURSELF AS A DOT ON THE GIANT PLANET OF EARTH. SEE YOURSELF FROM OUTER SPACE. WHAT HAPPENS TO YOUR SELF-LIMITING BELIEFS FROM WAY OUT THERE?

> HOW DO YOU FIT INTO THE COSMOLOGICAL SETTING—TO THE TIME AND SPACE AROUND YOU?

> HOW ARE YOU INTERACTING WITH THE INTERCONNECTED WEB OF LIFE AROUND YOU? HOW ARE YOU HEALING OTHERS WITH YOUR GIFTS OR PASSIONS? CAN YOU USE THEM TO HELP, TO BUILD COMMUNITY, OR TO BE PART OF A LARGER COMMUNITY?

Consider the voices of your ancestors. Picture those who came before you. Go back through five, seven, or nine generations in your mind.

- WHAT ARE THEIR STORIES?
- WHAT GIFTS CAN THEY OFFER YOU?
- DID THEY MAKE MONEY EASILY?
- DID THEY TEND THE HOUSE WELL?
- WERE YOUR ANCESTORS OPPRESSED?
- WERE THEY FARMERS OR MERCHANTS?
- HOW MANY ARTISTS WERE IN YOUR FAMILY? QUILTERS? DANCERS?
- WHAT WERE THE CREATIVE CRAFTS OF YOUR PEOPLE?

31 DECENTER YOURSELF 119

FROM WHERE ON THE PLANET DID THEY COME?

Are you aware of a connection of your current creative art form to something from that place? Do some research.

Go back further—where are your people from seven generations ago? Tape a map of that region here to remind you of where you came from.

Take a picture of an old photo (or photos) of your ancestors and print it out or photocopy it. **TAPE IT HERE** so their wisdom will guide you.

SPARK 32

TRUST YOURSELF

Through this book, you have learned many things about yourself.

You have learned a few of the mechanical aspects of creativity, such as finding your creative time of day and how to make your creative space. You have uncovered a few things about yourself and your past that have blanketed and hidden your creativity from you, and you have begun to let them go. You have learned about how to present and share your work and shine your light.

I HOPE YOU HAVE LEARNED THAT NO MATTER WHAT, YOU ARE GOOD ENOUGH EXACTLY AS YOU ARE RIGHT NOW, AND YOUR LIFE EXPERIENCE WILL FILL YOUR WORK WITH YOUR SPIRIT.

Now that you have read this book, let me tell you one last thing to take with you on your adventure: Nothing you need to know is in this book or any other. It's not in a class or at the museum or at the art supply store.

32 TRUST YOURSELF 123

DO THIS How do I practice self-trust?

RESOURCES
My Favorite Things

ONLINE CLASSES
Creative Spark
Masterclass
Skillshare
Creativebug
Creative Live
My Modern Met

ART SUPPLIES
Blick.com
Jerry's Artarama
Cheap Joe's
Michael's

BOOKS ON COLOR
Color: A Natural History of the Palette by Victoria Finlay
The Secret Lives of Color by Kassia St. Clair
Make Ink: A Forager's Guide to Natural Inkmaking by Jason Logan and Michael Ondaatje
The Brilliant History of Color in Art by Victoria Finlay

DRAWING
Drawing on the Right Side of the Brain by Betty Edwards

CARRIE'S INSPIRATION

Zen Mind, Beginner's Mind by Suzuki Roshi

Writing Down the Bones by Natalie Goldberg

Ratatouille (the movie)

The Secret Life of Walter Mitty (the movie)

Any and every Marvel movie

Any talk, podcast, or book by Brené Brown

The Instagram page of Tabitha Brown

Documentaries on mushrooms such as *Fantastic Fungi*

Wabi-Sabi for Artists, Designers, Poets & Philosophers by Leonard Koren

The Biggest Little Farm (documentary)

The Botany of Desire by Michael Pollan

The art of Kiki Smith, Kara Walker, Frida Kahlo, Pierre Bonnard, Kehinde Wiley, The quilters of Gee's Bend, Shepard Fairey, Henri Matisse, Mark Rothko, Doug Baulos, Elizabeth Catlett, Jean Michel Basquiat, Andy Goldsworthy, Hilma Af Klint, Carrie Mae Weems, Banksy, Beatrice Wood, James Turrell, Lucie Rie, any and all cave paintings

The music of Meklit, Nala Sinephro, Nick Mulvey, GoGo Penguin, Phoebe Bridgers, Florence + The Machine, Michael Kiwanuka, George Winston, Ben Howard, Kaki King, Erik Satie, Radiohead, Thom Yorke, Marian Hill, Lost Horizons, Vierre Cloud, Mac Miller, and Ariana Grande.

About the Author

Many years ago, Carrie Bloomston's grandmother, Nanu, somewhat harshly told her, "You're wasting Carrie." This was a few years after she graduated from Rhode Island School of Design and built a life with a beautiful man in the Sonoran Desert. She wasn't living up to her potential or calling on her inner artist. Instead, she painted murals for her day job. It required little of her soul, and the pay was great.

Fast forward to the financial collapse of 2008 and a life-storm of enormous proportions, and Carrie started sewing for her babies because it felt good. Her inner artist roared back. Her love of making woke up. She learned to quilt and designed whimsical things. She became a creativity enabler, a textile designer with nine collections for Windham Fabrics, authored *The Little Spark—30 Ways to Ignite Your Creativity*, and became a middle school art teacher at an independent school in Phoenix, Arizona.

CARRIE NOW SPENDS HER TIME HELPING PEOPLE DISCOVER THEIR INNATE CREATIVITY. SHE WILL HELP YOU STEP INTO THE FULLNESS OF YOURSELF, TOO. IF YOU CAN LIVE LIFE WIDE AWAKE, YOU CAN BE AN ARTIST. CREATIVITY IS THE EASY PART. WAKING UP TAKES COURAGE.

Carrie lives with her favorite people (her therapist/artist husband and two incredible kids) in their little house in the desert. Usually, you can find them all doing laundry and watching movies together.

ABOUT THE AUTHOR 127

Follow Carrie on Instagram @carriebloomston and read more at her website, www.carriebloomston.com

Photo by Jill McNamara

Want even more creative content?

Visit us online at **ctpub.com**

Make it, snap it, share it

#ctpublishing